DATE DUE

			PRINTED IN U.S.A.

An Introduction to

Medieval Ivory Carvings

An Introduction to

Medieval
Ivory Carvings

Paul Williamson

Assistant Keeper, Department of Sculpture
Victoria & Albert Museum

LONDON: HER MAJESTY'S STATIONERY OFFICE

To my Mother and Father

ACKNOWLEDGEMENTS

I should like to thank first John Mitchell and Sandy
Heslop, both of the University of East Anglia, for many
helpful discussions. My knowledge of Gothic ivory carving
has increased greatly due to conversations with Malcolm
Baker, Danielle Gaborit-Chopin, Charles Little, Richard
Randall Jr, and Neil Stratford. At the Victoria & Albert
Museum I should like to thank the staff of the Department
of Sculpture, Lucy Cullen, Ben Curran, Leonard Joyce and
Anthony Radcliffe, for all their practical help, and Stanley
Eost, who took the colour photographs.
 Lastly, although I have not agreed with all his opinions,
I owe a great debt to John Beckwith.

Designed by Andrew Shoolbred
to a series design by Humphrey Stone
Edited by Anthony Burton
Produced by Pitman Books Ltd, London.

ISBN 0 11 290377 0

Dd 696414 C25

Introduction

The importance of medieval ivory carving lies in the fact that so little monumental sculpture of the highest quality survives from the years 500–1050. By turning to the art of the ivory carver it is possible to reconstruct, almost without a break, the stylistic and iconographic changes that occurred in the Middle Ages.

Ivory has been used for the creation of artifacts since prehistoric times. It was not only the tusk of the elephant that was used: in the medieval era walrus tusk became popular, especially in the North, and whalebone was also employed. But it was elephant ivory that was most prized from early times, and this is borne out by many references to it in the literature of the Greeks and Romans. Pliny, writing in the first century AD refers to it thus:

> Their [the elephants'] teeth are very highly prized, and from them we obtain the most costly materials for forming the statues of the gods.

The high cost of the material was dictated by the distance it had to travel, and as it was so expensive it tended to be used only for very important carvings such as monuments to the gods. It was sometimes used as an inlay for furniture, although carved bone usually sufficed for this purpose. We know that the best Greek sculptors carved statues in ivory as Pliny mentions, and Pheidias (in the fifth century BC) is recorded as having worked on many. Pausanius, Athenaeus and Strabo note that the ivory was obtained from India, Ethiopia, Libya and Ceylon.

The Greeks and Romans did not have to buy all the ivory that came into their countries: vast amounts were brought back after foreign campaigns and conquered enemies often paid tribute to the Romans with gifts of ivory and precious metals. This is well illustrated in an ivory carving of the sixth century AD, now in the Louvre in Paris, where a conquered barbarian is to be seen bringing an elephant tusk to the triumphant Emperor, seated on his horse in the plaque above (FIGURE 1). Because ivory came from distant countries the supply was likely to be

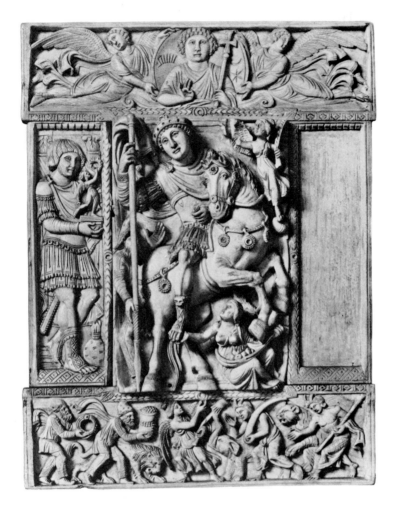

FIGURE 1
Half of an imperial diptych.
Constantinople, first half of the
sixth century. Paris, Musée du
Louvre.

very vulnerable in times of war: in spite of stock-piling, supplies inevitably ran out, and examples of the ivory carver's art in these periods are rare. There is not a single Byzantine ivory carving that can be securely dated in the period between the middle of the sixth century and the beginning of the tenth: although this is partly due to iconoclasm (the banning of religious image-making between 726 and 843), there can be no doubt that the rise of Islamic power in the East, and the ensuing hostilities, contributed greatly to the situation. It must be true also that the popularity of objects carved in ivory was subject to fashion – this could explain the lack of ivory carvings in the first half of the thirteenth century and during the Renaissance.

The History of Ivory Carving in the Middle Ages

Late Antique

The first centuries of the Christian era were dominated by the Romans. Although by the early fourth century the Roman Empire was under constant pressure from barbarians, the art of the capital, Rome, still exerted a massive influence. When Constantine the Great transferred the capital of the Empire from Rome to Constantinople in 330, and Christianity became established as the official religion of the Romans in 380, their art became more polyglot as diverse stylistic and political influences came to bear on it. The value of ivory to the Romans has already been mentioned, and in accordance with its worth it was only used for carvings commissioned by wealthy and influential patrons. The Symmachi-Nicomachi diptych, the Anastasius diptych and the Orestes diptych (PLATES 1, 3 & 4) clearly fall into this category. The Symmachi-Nicomachi diptych is an especially important historical document as it reflects the last efforts by a small group of patrician families to preserve the old Roman cultural heritage in the face of the new religion. In 384, Theodosius issued an edict forbidding the presentation of ivory diptychs by anyone below the rank of consul. After this date it was customary for the consul, on elevation to office (in either Rome or Constantinople), to present diptychs to friends and high-ranking officials; the reverse of each leaf was covered with wax and a message was inscribed – in effect, they were ostentatious greeting-cards. The earliest surviving consular diptych is dated 406 (the Probus diptych in the Cathedral Treasury at Aosta) and the last 540, as the consulate was abolished in 541. Between these dates 44 diptychs are known: 10 are anonymous, the other 34 represent 18 different consuls. The consular diptychs are, therefore, an important group of ivories since nearly all can be dated precisely to the first year of the consul's office: their carvings illustrate the development of style from the beginning of the fifth century to the middle of the sixth. Because of this well-documented chronological development other, undated, ivory carvings can be dated reasonably closely by comparison.

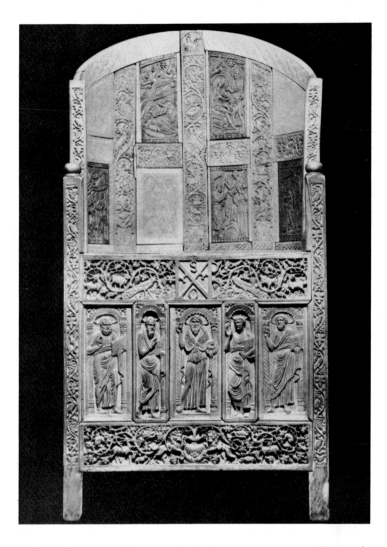

FIGURE 2
The Throne of Maximianus.
Constantinople, c. 547.
Ravenna, Archiepiscopal
Museum.

The Christian faith provided the ivory carver with ample opportunity to practise his art. The early Christians needed book covers for their bibles, ivory pyxides (cylindrical boxes) for the unconsecrated host and relics, and even grander objects such as Bishop's thrones. Perhaps the most impressive ensemble of ivory carvings from early Christian times is that on a throne carved for Archbishop Maximianus of Ravenna (FIGURE 2). Probably executed just before 550, the throne has scenes from the lives of Christ and the Virgin, episodes from the story of Joseph, and at the front St John the Baptist with the four Evangelists. Because of the unsurpassed quality of the work, the throne must come from the metropolis, Constantinople. It is quite possible that it was a gift from the Emperor, Justinian, to Maximianus at the time of the dedication of the church of San Vitale in 547. Nor is it suprising that the most splendid ivory

carvings of early Christianity should come during the reign of Justinian I (527–565); he was a great patron of the arts and was responsible for the rebuilding of the church of Hagia Sophia in Constantinople, which even today is one of the most magnificent buildings in the world.

Between the middle of the sixth century and the beginning of the ninth few pieces of ivory carving survive. This is odd in view of the fact that there is a large corpus of extremely sumptuous silverware from the time of Heraclius (610–641), and must be due to the lack of raw materials. It is likely that the rise of Islamic power after 640 had a direct effect on the supply of ivory to the West, cutting off the trade routes from India and severely restricting the African trading connections. In addition, iconoclasm clearly had a disastrous effect on figural sculpture and painting in the eighth and ninth centuries.

In the North, ivory could be replaced by whalebone or walrus ivory, known as morse. The Franks casket (in the British Museum, except for one side, now in the Museo Nazionale in Florence) was carved from whalebone around the year 700. It shows scenes drawn mainly from Pictish legend and Roman folklore – but also includes an isolated Christian scene, the Adoration of the Magi – and illustrates the insular and Celtic character of the Anglo-Saxon art of Northumbria (FIGURE 3). It is interesting that there is a mention of whaling being carried out by Northmen in the account of Ochthere's voyage which was given to King Alfred in the ninth century.

FIGURE 3
The lid of the Franks Casket. Whalebone. Northumbrian, about 700. London, British Museum.

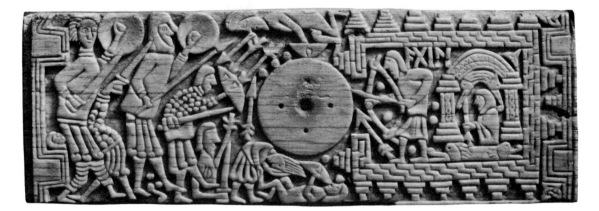

Carolingian and Ottonian

Charlemagne, crowned Holy Roman Emperor in 800, was determined to re-establish the cultural atmosphere of the Christian, late Roman Empire. To this end, artists working under his patronage copied and re-interpreted late antique prototypes in manuscript illumination, building programmes and ivory book covers. It was not just a pictorial and architectural renaissance

9

that occurred, for Charlemagne surrounded himself with men of learning such as Alcuin from York, who taught the Emperor rhetoric, dialectic, astrology and mathematics. Charlemagne taught himself Latin, but could never master the art of writing. There is mention in Charlemagne's two biographies, by Einhard and Notker the Stammerer, of his desire to emulate the buildings of Rome – even to the extent of taking columns from Ravenna and Rome to furnish the Cathedral at Aachen, his capital. Likewise, in some cases consular diptychs of the sixth century were re-used for book covers: several Carolingian ivory plaques have the remains of a consular inscription on their reverse. Sometimes sixth-century ivories were set into new surroundings, as were the six reliefs assimilated onto the pulpit in Aachen Cathedral.

The Late Antique heritage was used in more than just a practical way, as the Carolingian artists borrowed iconographic, stylistic and compositional features from the earlier works. The covers of the Lorsch Gospels (PLATE 5) are an excellent case in point. The front cover is now in the Victoria & Albert Museum, the back in the Museo Sacro of the Vatican. In its five-part format the composition derives from sixth-century book covers, examples of which are in the Bibliothèque Nationale in Paris and in the museum at Etschmiadzin. There has been considerable debate about whether the covers actually incorporate any late antique carving. Charles Rufus Morey first suggested that the top panel in the Vatican cover was the only surviving part of a sixth-century book cover and that the rest (the other four panels) had been carved to replace the worn-out originals. The way the top panel has been cut back at the corners and the side panels carved diagonally to fit this modification suggests that he is probably right. However, there can be no doubt that the covers owe a debt, both stylistically and compositionally, to sixth-century originals such as the front of Maximianus's throne in Ravenna.

The revival of ivory carving under the Carolingians was not solely due to Charlemagne's desire to re-create the splendour of the Christian Late Antique – it was made possible by his international links with the Eastern powers and the fleets of the Mediterranean. Einhard, in his *Life of Charlemagne*, tells of the Emperor's friendly relations with Alfonso II, the King of Galicia and Asturias, and, more importantly, with Harun-al-Rachid, King of the Persians. He goes on to describe how Harun showered Charlemagne with gifts of all sorts, and even presented him with an elephant. Charlemagne also kept on good terms with the Emperors at Constantinople, with many messengers travelling between Aachen and the Byzantine capital.

The efflorescense of ivory carving under Charlemagne started at the end of the eighth century, as may be illustrated by the

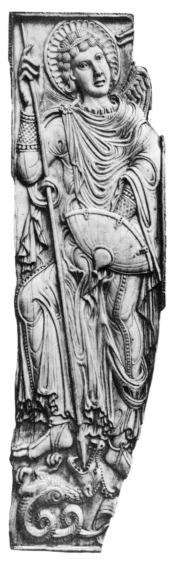

FIGURE 4
The Archangel Michael. Aachen
(Court School), c.800–810.
Leipzig, Museum des
Kunsthandwerks.

covers of the Dagulf Psalter, intended for presentation to Pope Hadrian I (772–795). The ivory covers of the Lorsch Gospels probably date to about 810 (excepting earlier fragments), and exemplify the 'Court School' style prevalent then: this is also seen in painting, in a group of illuminated manuscripts the most splendid of which are now in Paris (the Soissons Gospels), London (the Harley Gospels), Trier (the Ada Gospels), and Rome and Bucharest (the Lorsch Gospels). There are a few ivory carvings that belong to this Court School: two of the most beautiful are the St Michael in the Museum des Kunsthandwerks, Leipzig (FIGURE 4), and a plaque showing the Virgin and the Apostles at the Ascension in the Hessisches Landesmuseum in Darmstadt, which are very close stylistically to both the Lorsch Gospels covers and the above-mentioned manuscripts.

What started under Charlemagne continued during the reigns of his successors, Louis the Pious (died 840), Lothair I (died 855) and Charles the Bald (died 877). Regional schools emerged, the most famous being those at Metz, Tours and Rheims. Large numbers of ivory carvings were produced, not just as book covers: indeed, two of the most significant works of the middle of the ninth century, the *Flabellum* of Tournus (Museo Nazionale, Florence) and the Throne of Charles the Bald (the *Cathedra Sancti Petri*) in St Peter's, Rome, are unique objects. The inscribed plaques on the throne, showing scenes of the labours of Hercules and representations of the constellations, bear witness to the knowledge the Carolingians still preserved of pagan mythology: it is interesting that scenes such as these were considered suitable for the decoration of a royal throne, and that several manuscripts concerned with the same type of subject (for instance, a copy of Cicero's *Aratea* now in the University Library, Leiden) must have been courtly commissions. Clearly, by this time Christianity was so strongly established that it was no longer considered heretical to have an interest in classical literature and legend. Indeed, if it were not for the Carolingian copies made from antique texts, much of classical literature known to us today would have been lost.

The Carolingian dynasty had spent itself by the end of the ninth century, and it was not until after the middle of the tenth century that another strong ruling-class became evident in northern Europe. The Ottonians emerged at a time when Europe was fragmenting into the form we know today. Whereas the Carolingian Empire spread far and wide, the Ottonians were essentially a German clan: the Ottos were never happy as Holy Roman Emperors, encountering hostile opposition in Rome on several occasions. That is not to say that they were insular and opposed to foreign communication: their links with the Byzantines are well known, Otto II marrying the

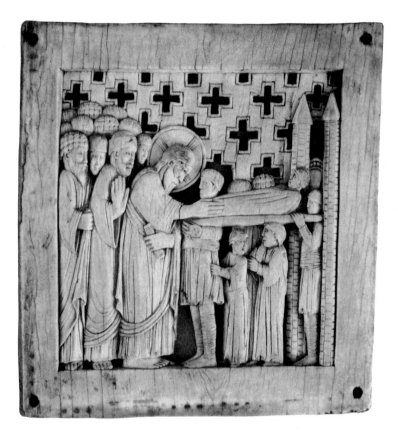

FIGURE 5
The Raising of the Widow of Nain's Son. Milan (?), c.970. London, British Museum.

Byzantine Princess Theophanu in 972. In their art they inherited the Carolingian tradition of narrative, but the style had radically changed. In the plaques carved for Magdeburg Cathedral in the time of Otto I (962–973), once thought to have decorated an *antependium* (or covering for the front of an altar), but more probably a door, the figures have become much squatter and more block-like, and the draperies hang inert, with none of the agitation characteristic of the earlier period (FIGURE 5). Now scattered among the museums of Europe and the Metropolitan Museum in New York, the Magdeburg plaques are thought to have originated from Milan on the strength of their similarity with two slightly later ivory *situlae* (holy water buckets), connected with Milan by inscription (see PLATES 7a and 7b).

Byzantine

After the period of iconoclasm, a renewal of religious figurative art in the Byzantine East was to be expected. From the reign of Basil I (867–886) to the death of Basil II in 1025 the Byzantine Empire was a strong, unified force which eventually stretched from South Italy in the West to Armenia in the East. With this military strength came cultural stability and by the tenth century all branches of the arts were thriving to such an extent that the

period became known as 'the Macedonian Renaissance', named after the ruling house of the Macedonians. In the reign of the scholar Emperor, Constantine VII Porphyrogenitos (913–959), a renewed interest in classical culture manifested itself in the arts of the time, most notably in manuscript illumination and ivory carving. As the Empire flourished the old trade-routes were consolidated and protected, and ivory must have been imported in great quantity again. The extent of this 'renaissance' is strikingly illustrated by a group of caskets made in Constantinople at the end of the tenth century and the beginning of the eleventh, the most famous of which is the Veroli casket (PLATE 9) in the Victoria & Albert Museum: its sides are decorated with scenes from classical mythology, including the sacrifice of Iphigenia and the rape of Europa. Side by side with these secular carvings, Christian objects of devotion were produced in large numbers. A substantial group of diptychs and triptychs survive from the tenth and eleventh centuries, the most magnificent examples belonging to the so-called 'Romanos Group', named after a plaque showing the Coronation of Romanos and Eudocia by Christ, now in the Cabinet des Médailles in Paris. Three beautiful triptychs (in the Louvre, the Vatican and the Palazzo Venezia in Rome) with Christ in the upper register of the central panel, surrounded by standing saints, and decorated with a cross on the back of the central panel, are the major pieces in this group. There has, however, been considerable debate about whether the ivories in this group should be regarded as homogeneous and, if so, whether they should be dated to the reign of Romanos II (959–963) or Romanos IV (1068–1071), as both were married to Empresses named Eudocia: recent research has placed the Palazzo Venezia triptych in the tenth century, the Vatican triptych at the beginning of the eleventh and the Louvre triptych (FIGURE 6) in the 1060's.

Steatite, a softstone easily carved, became increasingly popular in the East after the eleventh century, gradually replacing ivory as a medium for smaller carved objects. It must have been considerably cheaper and was clearly available in greater quantities than ivory, but the quality of the carving very rarely matches that found in ivories, most of it being of a mass-produced standard: ivory was still reserved for the richest members of society and the Church. The metropolitan style and eastern elements of iconography spread westwards to the Byzantine dominions in Italy in the early eleventh century, and at the end of the eleventh century, in the ivory carvings produced south of Rome (see PLATES 12 and 13), there are still strong eastern overtones. The most impressive ensemble of ivory carvings in Italy from this time formed an *antependium* (or again perhaps a door) in Salerno Cathedral, where most of the plaques are still displayed. They show scenes from the Old and New Testament

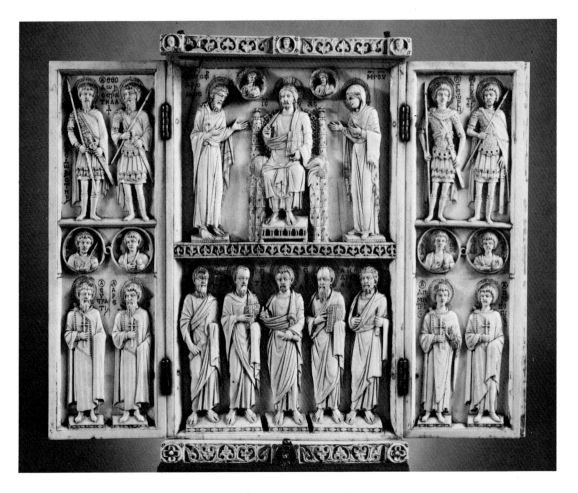

and match the iconographic treatment of the contemporary frescoes of S. Angelo in Formis, both probably reflecting the programme once seen in the now-destroyed cycle at Montecassino. Although Byzantine influence is clearly detectable in these works, there are also distinct traces of the local tradition and artistic character of South Italy. It is interesting to compare the treatment of the New Testament incidents in the Salerno ivories with the same scenes in the Magdeburg group (mentioned earlier). Although the episodes are contained within the same square format, the figures in the Salerno ivories are taller and more elongated than their Ottonian counterparts, bearing no spatial relation to their architectural setting.

Byzantine influence was also felt in the Veneto in the twelfth century. The Venetian link with Constantinople is seen in the mosaic decoration at San Marco; an ivory carving of the Last Judgement (PLATE 14), very close to the mosaic on the West wall of Torcello Cathedral, also betrays its debt to eastern iconographic programmes.

FIGURE 6
The Harbaville triptych.
Constantinople; middle of the eleventh century (?). Paris, Musée du Louvre.

Romanesque

The majority of Northern Romanesque carvings were executed
not in elephant ivory, but in walrus ivory: English Romanesque
carvings were virtually never of elephant ivory. It is not without
significance that two elephant ivory carvings often assigned to
England have also been attributed to other countries by some
scholars (see PLATES 23 and 24a & b). Nor was the walrus the
only substitute for the elephant, whalebone often being used.
The Basques in North Spain had a thriving and important whal-
ing industry by the twelfth century, but it is most likely that
other North European countries simply used the whales that
had been stranded on their beaches. Unfortunately, evidence
regarding whaling and walrus-hunting is scarce and little is
known about the sales and centres of trade of this industry.
However, it is certain that herds of walruses were to be found
much further South than they are today and that large-scale
massacres greatly reduced their numbers in the Middle Ages.

England occupied a central position in the history of Roman-
esque ivory carving. From the second half of the tenth century
(after the Viking invasions) the great monastic houses of Eng-
land, especially Winchester, Canterbury and St Albans, actively
encouraged and supported the production of works of art made
for the glory of God. Great schools of manuscript illumination
attached to the abbeys were established, and side-by-side with
the scribes and illuminators worked the men responsible for
ivory carvings. They carved book covers, croziers, tau-crosses,
pyxides, liturgical combs, and crosses. That manuscript illumi-
nation and ivory carving were closely linked is proved by com-
paring the treatment of the Nativity in the Benedictional of St
Ethelwold (now in the British Library, and dated to 980) with
the same scene on an ivory panel now in the Merseyside County
Museums in Liverpool. Ultimately they both owe a debt to the
Continent, in particular the schools of Rheims and Metz (it is
worth remembering that the Utrecht Psalter, produced in
Rheims before 825, was in England in the tenth and eleventh
centuries), but the English style was to become as individual as
any other on the continent during the eleventh and twelfth
centuries. It must be noted that England and the Continent,
especially North France, were extremely closely linked at this
time (even more so after the Norman Conquest) and that just
as the English scribes and ivory carvers were influenced by the
manuscripts that were brought back from the Continent by the
dignitaries of the monasteries and abbeys, so works of English
craftsmanship were taken abroad and much admired. It is not
surprising then to find that ivory carvings in a very similar style
to English works were produced on the north coast of France
– at St Omer, for example, where the 'Winchester Style' was
copied and modified. In the eleventh and twelfth centuries there

was such an unprecedented exchange of ideas, both stylistic and iconographic, that at times it is difficult to tell where an ivory carving comes from. Artists travelled widely and had ample opportunities to be impressed by what they saw and to copy foreign works. One such example illustrates this point perfectly. A document in the University Library at Chicago tells us all about the foundation of a church in Herefordshire, at Shobdon, by Oliver de Merlimond between the dates 1131 and 1143. The document mentions that at the beginning of the building programme at Shobdon Oliver went on a pilgrimage to Santiago de Compostela in Spain, by land via France. Although Shobdon Church was demolished in the eighteenth century, its two doorways and the chancel arch were saved and re-erected in Shobdon Park. They are now so badly weathered that it is difficult to interpret the decoration, but earlier photographs and casts made in the middle of the last century enable us to appreciate the amazing mixture of styles present. Clearly, what Oliver (and perhaps a sculptor travelling with him) had seen in western France and northern Spain had contributed greatly to the style of decoration in his finished church. Nor did it end there: Professor George Zarnecki has shown that in sculptures at Kilpeck Church (also in Herefordshire), finished in around 1150, there are unmistakable elements of Spanish style, and even a direct quote from the main doorway at Compostela.

The implications are manifold: can an ivory with heavy Spanish stylistic overtones be assigned to England, with the explanation that the English carver was influenced by what he or somebody else saw while travelling abroad? Usually, the provenance of a particular ivory can only be traced back to the mid-nineteenth century and its country of origin can only be deduced by a process of informed speculation. Such has been the case with two well-known pieces, both in the Victoria & Albert Museum: the Adoration of the Magi in whalebone, and the Deposition from the Cross (PLATES 17 and 23). The Adoration of the Magi has most often been attributed to England (or 'Channel School') and dated to the late eleventh century, although the closest parallels, especially iconographic, are Spanish. The gauffered coif (the headgear of the Virgin), the peculiar architecture and the appearance of the Magi can all be most closely paralleled in Spanish sculpture of the eleventh century and, as stated earlier, there is no reason to doubt that the Spaniards were able to obtain whalebone, as the Basques had one of the few whaling fleets in Europe. Added to this, the ivory closest in style to the Adoration of the Magi is a carving that has always been thought of as Spanish, a plaque showing the Virgin and Child, now in the Louvre. Concerning the Deposition from the Cross, which is presently attributed to Herefordshire (and related to sculpture at Kilpeck, which, as we have

seen, was heavily influenced by Spanish sculpture), one is left to ponder in what circumstance the carving was executed. There was no court or abbey workshop capable of producing such a work in Herefordshire in the middle of the twelfth century and the sculptors working on a large scale moved very quickly – all their work in and around Kilpeck was completed in about 20 years. In addition, the carving is in elephant ivory, which as I have already pointed out was virtually unused in English Romanesque carving; in Spain it was the norm.

There are considerable numbers of Spanish ivory carvings, many produced under courtly patronage, and the grandest of these works is the magnificent ivory crucifix given to the Colegiata de San Isidoro at León by King Fernando I and Queen Sancha in 1063, now in the Museo Arqueológico in Madrid (FIGURE 7). Here there is an intentional display of conflicting scales in the large figure of Christ (h.30cm) and the minute treatment of the animal ornament around the edges and on the back of the cross. It is interesting to compare the treatment here with that of the so-called 'Bury St Edmunds Cross', now in the Metropolitan Museum in New York, and probably dated around 1135 on the strength of its similarity with the Bury Bible. The English example consists of a well thought-out decorative programme, where the individual scenes on the tips of the arms, the central rose and upright combine to make up a sophisticated narrative method. There is none of this on the Spanish cross – instead the back of the cross is filled with a wild habitation of beasts surrounded by lush foliate swirls.

In the north, ivory carvers were turning their attention to secular as well as religious objects. In Cologne and the lower Rhine, a very productive area in the late eleventh and early twelfth centuries, many gaming pieces were carved and exported throughout Europe, and it may well be that the fashion spread to England. The famous Lewis chessmen (now shared between the British Museum and the National Museum of Antiquities in Edinburgh) were either carved in the north of the British Isles or in Scandinavia, at the end of the twelfth century.

Gothic

In view of the fact that nearly all northern European carving had been executed in walrus ivory during the eleventh and twelfth centuries, it is all the more surprising to see the emergence of a massive industry in the carving of elephant ivory in Paris after the middle of the thirteenth. Between about 1180 and 1260 there are very few surviving ivory carvings, and it is unlikely that many were produced. This could be due to lack of raw materials: elephant ivory had already been scarce for 200 years, but perhaps by this time the herds of walruses had been

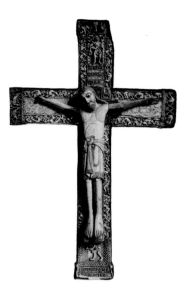

FIGURE 7
Altar cross of King Fernando and Queen Sancha (front), given in 1063. Madrid, Museo Arqueológico Nacional.

virtually wiped out too. The gap was probably also due to fashion. The years 1140–1270 were the golden years of French monumental sculpture and it is feasible that small-scale devotional objects (such as were often made in ivory) were not in demand. Most church treasuries must have been full of crucifixes, book covers, and statuettes in elephant and walrus ivory by the end of the twelfth century and would not have been in need of any more. It is significant that when ivory was used again in vast quantities, patronage had changed. In the late thirteenth century the ivory carving industry in the Ile-de-France was totally geared towards producing large numbers of objects for private devotion, such as small diptychs and triptychs with scenes from the Passion of Christ, and ivory statuettes of the Virgin and Child. The richer the patron, the grander the object. Carvings such as the Coronation of the Virgin group and the Deposition from the Cross group in the Louvre could only have been commissioned by the most courtly patrons, and were executed by the most talented artists of the time. In the fourteenth century, secular objects – carved mirror cases (see PLATE 27), combs or caskets – were made in great numbers for a public brought up on tales of Romance and chivalry: the scenes reflect the taste of the time, illustrating stories such as the then well-known 'Romance of the Rose'.

Although the strongest impulse came from Paris, many other centres of ivory carving emerged. It is likely that large numbers of craftsmen working in ivory in other countries were trained in Paris; the 'Kremsmunster Master', an Austrian artist at the end of the fourteenth century, certainly was. England produced some notable examples of the ivory carver's art in the fourteenth century. The Salting diptych in the Victoria & Albert Museum (PLATE 25) and the Grandisson triptych in the British Museum (dated 1369) reveal a monumental approach seldom seen in French works. In Italy there is evidence that sculptors of large-scale works embarked on ivory carving occasionally: we know that Giovanni Pisano carved the large ivory Virgin and Child for the high altar of Pisa Cathedral in 1298–9 (it is now in the Museo dell'Opera del Duomo at Pisa), and he is most likely to be the artist responsible for the figure of the crucified Christ in the Victoria & Albert Museum (PLATE 30).

The treatment of the standing Virgin and Child in the thirteenth century provides an interesting and particularly illuminating example of how sometimes materials exercise control over style and composition in finished works of art. In a large ivory carving such as the Sainte Chapelle Virgin, now in the Louvre, which measures 41cm, a large amount of the tusk of the elephant had to be used. Because the carver of the figure wanted to use as much of the tusk as possible he was forced to integrate the natural curve of the tusk into his statuette (FIGURE

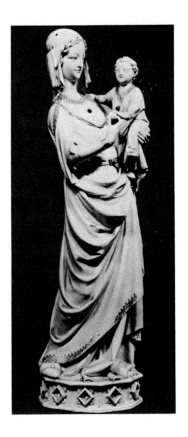

FIGURE 8
Virgin and Child of la Sainte-Chapelle. Paris, c.1250–1260. Paris, Musée du Louvre.

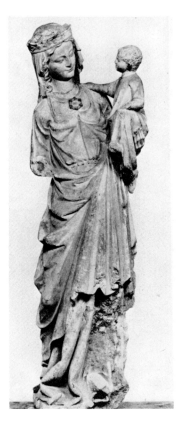

8), giving it a very perceptible lean: this was true of many of the larger Virgin and Child groups (see the seated Virgin and Child in the Victoria & Albert Museum, PLATE 29). What is perhaps even more instructive is to see how a trait such as this, which should be peculiar to only one medium (ivory), is transmitted to other media and establishes a style of the time. If one compares the Sainte Chapelle Virgin with a stone statue of the Virgin and Child in Compiègne (FIGURE 9), sculpted in around 1270, it seems likely that the stone carver copied the lean of an ivory statuette, even though he was not being dictated to by the material he was using. Therefore, this 'contrapposto', a characteristic of Gothic art seen in stone and wood sculpture and in manuscript illumination in the late thirteenth and fourteenth centuries, most probably came about purely as a result of the shape of an elephant's tusk.

At the end of the fourteenth and the beginning of the fifteenth century the production of ivory carvings gradually ceased. The family of the Embriachi and their workshop in North Italy continued to produce altarpieces and marriage caskets well into the fifteenth century, carved from bone and fitted together, sometimes into very large complexes. But these works had a mass-produced character and were very dry compared with what had gone before. It was not until the end of the seventeenth century that the art of the ivory carver was established once again.

FIGURE 9
Virgin and Child from Sainte-Corneille. Compiègne. Stone. c.1270. Compiègne, Saint Jacques.

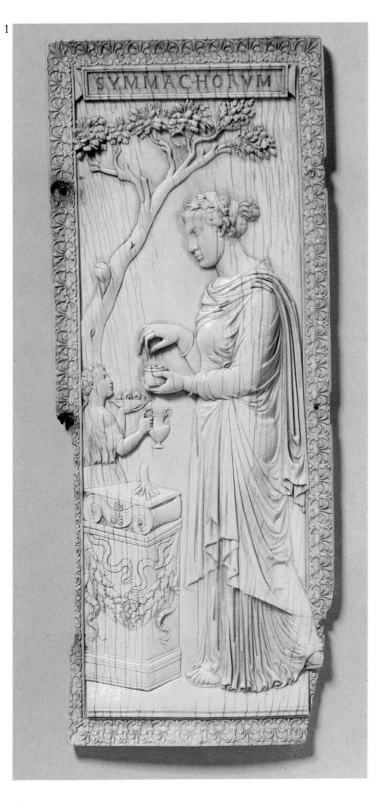

The Symmachorum panel

PLATE 1
The Symmachi Panel. Rome; end of 4th century.
H. 11½ in, w. 4¾ in (29.5cm × 12cm).
212–1865

This is the right half of a diptych that may have been issued to commemorate a marriage between the families of the Symmachi and the Nicomachi in Rome in either 393/4 or 401. The left-hand leaf is in the Musée de Cluny in Paris. A priestess of Bacchus, accompanied by a boy, stands before an altar and makes a sacrifice by sprinkling corns of incense onto the fire. In style and subject-matter the carving recalls works on a larger scale, produced under the Emperor Hadrian in the early second century AD.
See P. Williamson, *The Symmachi Panel*, Victoria & Albert Museum Masterpiece Sheet, 1980.

PLATE 2
An Apostle. Roman; middle of
the fifth century.
H. 4½ in, w. 2¾ in (11.5cm
× 7cm).
272–1867

There is an apostle of almost
exactly the same size and type
in the Louvre in Paris, and it
has been suggested that they
once formed part of an
altarpiece.

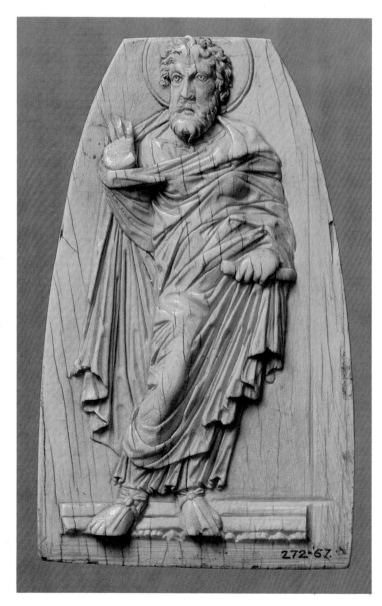

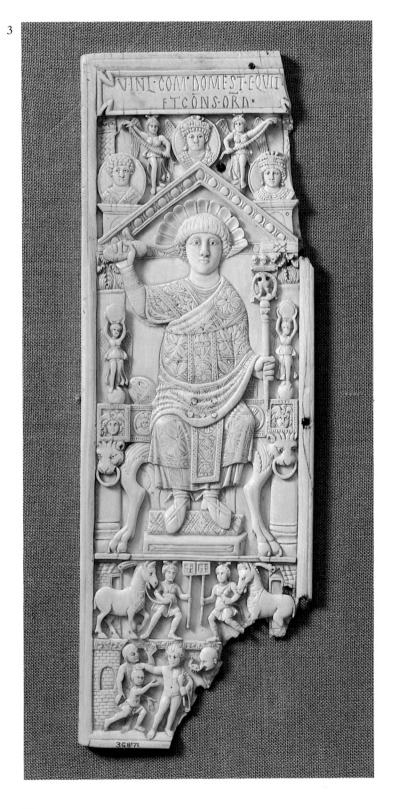

PLATE 3
Leaf of the Consular Diptych of Flavius Anastasius.
Constantinople; 517.
H. 14¼ in, w. 5 in (36.5cm × 13cm).
368–1871

The right leaf was formerly in the Antiquarium, Berlin, but was destroyed in the war. Anastasius is seated on the curule chair, holding the *mappa circensis* (which he dropped to start the games) in his upraised right hand, and a sceptre in his left. In the medallions below the inscription are the Emperor and Empress, Anastasius (in the centre) and Ariadne, and to the left, the other Consul. The inscription reads: V[ir] INL[ustris] COM[es] DOMEST[icorum] EQVIT[um] ET CONS[ul] ORD[inarius]. Below are scenes from the circus. The lower right-hand side was broken off sometime after 1759 as an engraving was made showing it complete at that time.

PLATE 4
Consular Diptych of Rufus Gennadius Probus Orestes.
Rome; 530.
H. (each leaf) 13⅜ in, w. (each leaf) 4⅝ in (34cm × 12cm).
139–1866

The Consul sits on the curule chair flanked by personifications of Rome and Constantinople. Portrait busts of Amalasuntha and her son Athalaric are above the inscription, which reads: RUF[ii] GENN[adii] PROB[i] ORESTIS. V[irii] C[larissimi] ET INL[ustris] CONS[ulis] ORD[inarii]. This is the last known consular diptych made in Rome, and it copies almost exactly that of the Consul Clementinus, made in Constantinople in 513 (now in the Merseyside County Museums, Liverpool).

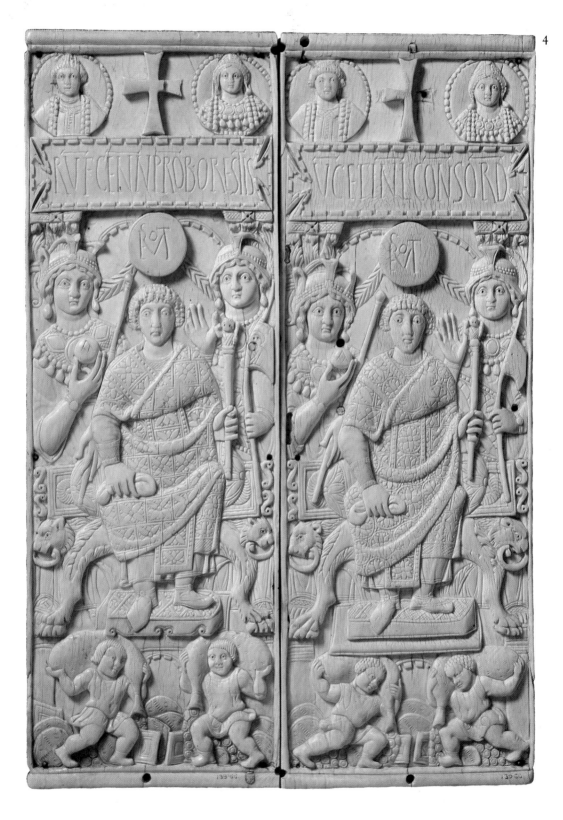

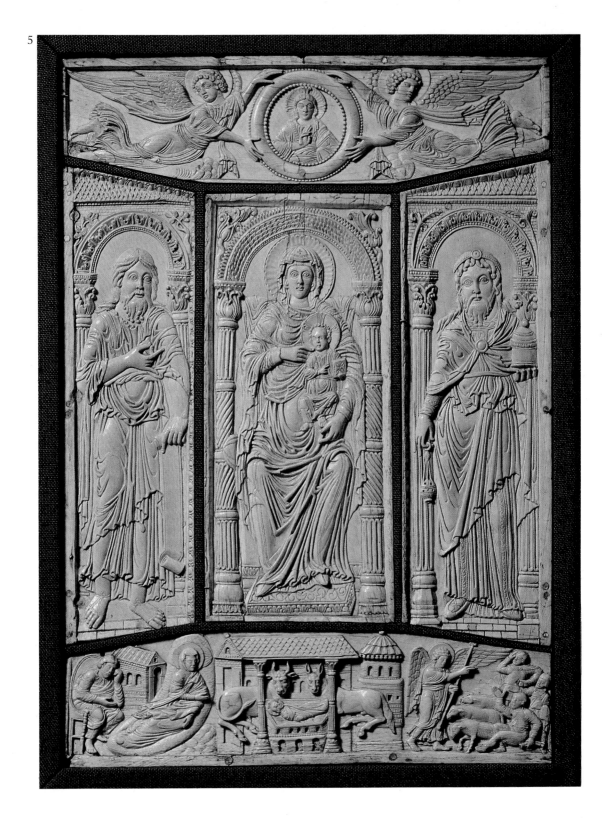

PLATE 5
The Front Cover of the Lorsch Gospels.
Aachen; about 810.
H. 15⅛ in, w. 10½ in
(38.1cm × 26.7cm).
138–1866

This bookcover once formed part of a copy of the Gospels from Lorsch Abbey. It shows the Virgin and Child flanked by St. John the Baptist on the left, and Zacharias on the right. Above, two flying angels hold a medallion of Christ, and below are represented the Annunciation to the shepherds and the Nativity. The other cover is now in the Vatican Museums, and shows Christ treading the beasts between two Archangels: on that cover two angels fly above holding a medallion containing a cross, and below are represented the three Magi before Herod and the Adoration of the Magi. It seems likely that the side panels were carved somewhat later than the top panel, as their sloping tops are shaped specifically to fit with the top panel, which was originally rectangular. See C. R. Morey, 'The Covers of the Lorsch Gospels. II. The Cover in the Victoria and Albert Museum', in *Speculum*, IV, 1929, pp. 411–429, and H. Schnitzler, 'Die Komposition der Lorscher Elfenbeintafeln', in *Münchner Jahrbuch der bildenden Kunst*, 1950, pp. 26–42.

PLATE 6
The Crucifixion. Metz; 3rd quarter of the ninth century
H. 8¼ in, w. 4¾ in (21cm × 12cm).
250–1867

The two busts in circles above Christ's head symbolize the sun and the moon; to the left of Christ are the figures of the Virgin and the Church

(represented holding a chalice to receive the blood of Christ); to the right are St. John and the Synagogue (with banner). Below them are Longinus with the lance and Stephaton with the sponge. On both sides figures emerge from their tombs, shown as circular *mausolea*, and in the lower

corners are the large symbolic figures of Earth and Water. The relief is dotted about its surface with small holes, which originally contained gold studs: some still exist. There are a number of reliefs in various museums very similar to this one: they would originally have formed part of a bookcover.

6

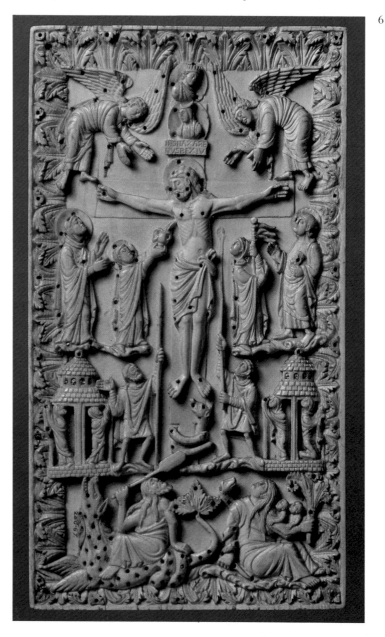

7

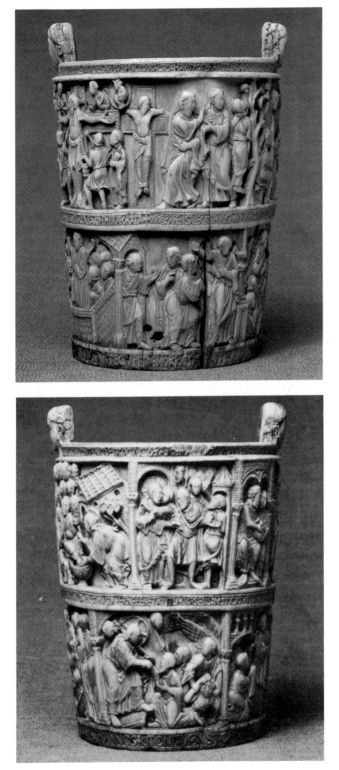

PLATE 7
The Basilewsky Situla. Milan;
980.
H. 6¼ in, d. 4¼–5 in (16cm
× 11–13cm).
A.18–1933

This *situla* (a bucket for holy
water) was presented to the
Holy Roman Emperor, Otto II,
in Milan in 980: the inscription
on the base refers to the gift
and wishes the Emperor well.
Situlae carved in ivory are
extremely rare, only four being
known – in New York
(Metropolitan Museum),
Aachen (Cathedral Treasury),
Milan (Cathedral Treasury) and
London. The closest in style to
the *situla* in the Victoria &
Albert Museum is the Milan
situla, carved at the order of
Gotfredus, Archbishop of
Milan, and also intended as a
gift to the Emperor in 980. The
scenes on the *situla* are from
the Passion and Resurrection of
Christ, and are identified by
inscription.
See J. Beckwith, *The
Basilewsky Situla*, Victoria &
Albert Museum, 1963.

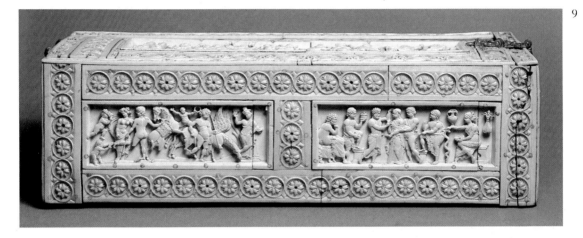

PLATE 8
Joshua receiving envoys from the people of Gibeon.
Constantinople; late tenth century.
H. 2⅞ in, w. 10⅝ in (7.5cm × 27cm).
265–1867.

On the left, Joshua receives two men who bow before him with hands covered: on the right he is to be seen beckoning to two advancing warriors. The plaque is made up of three pieces which were presumably joined together after the panels had been detached from a casket, to which they originally belonged. The scenes can be matched exactly in, and were probably copied from, the Joshua Rotulus manuscript in the Vatican Library (Cod. Vat. Palat. Gr. 431).

PLATE 9
The Veroli Casket.
Constantinople; late tenth/early eleventh century.
H. 4½ in, l. 15¾ in, w. 6 in (11.5cm × 40.5cm × 15.5cm).
216–1865

From the Cathedral of Veroli, South of Rome. Caskets of this type (known as Rosette caskets) are fairly common and are to be found in most of the great museums of the world: however, the Veroli casket is considered by many scholars to be the finest of the group. It must have belonged to a very wealthy individual, probably close to the Byzantine court. Carved with scenes from classical mythology, such as the Rape of Europa and stories of Bellerophon and Iphigenia, and peopled with nymphs and

centaurs, it testifies to the comprehensive knowledge the court artists held of classical literature.
See J. Beckwith, *The Veroli Casket*, Victoria & Albert Museum, 1962.

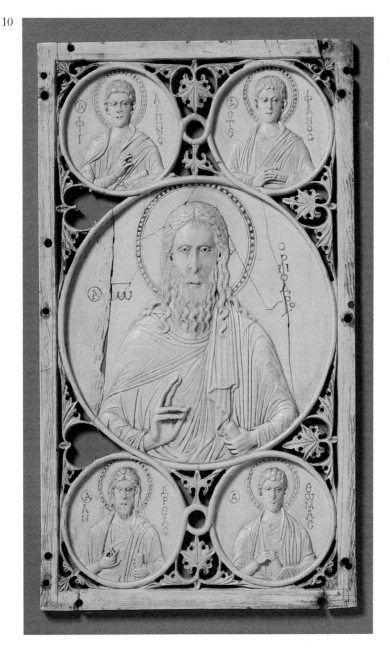

PLATE 10
John the Baptist, with (above)
*Saint Philip and Saint Stephen
and* (below) *Saint Andrew and
Saint Thomas.*
Byzantine; twelfth century.
H. 9¼ in, w. 5¼ in (23.5cm
× 13.5cm).
215–1866

The treatment of the drapery
and the facial types can be very
closely matched especially in
the figure of John the Baptist in
an early twelfth-century ivory
casket in the Museo Nazionale
in Florence.

PLATE 11
The Virgin and Child.
Byzantine; early twelfth
century.
H. 12¾ in (32.5cm).
702–1884

The statue represents the
Theotokos Hodegetria (the
Mother of God showing the
Way), and is unique in that it is
the only surviving Byzantine
ivory-carving in the round.
The head of the Christ-child is
a western restoration. See J.
Beckwith, 'Mother of God
showing the Way', A
Byzantine ivory statuette of the
Theotokos Hodegetria, in *The
Connoisseur*, CL, 1962, pp. 2–7.

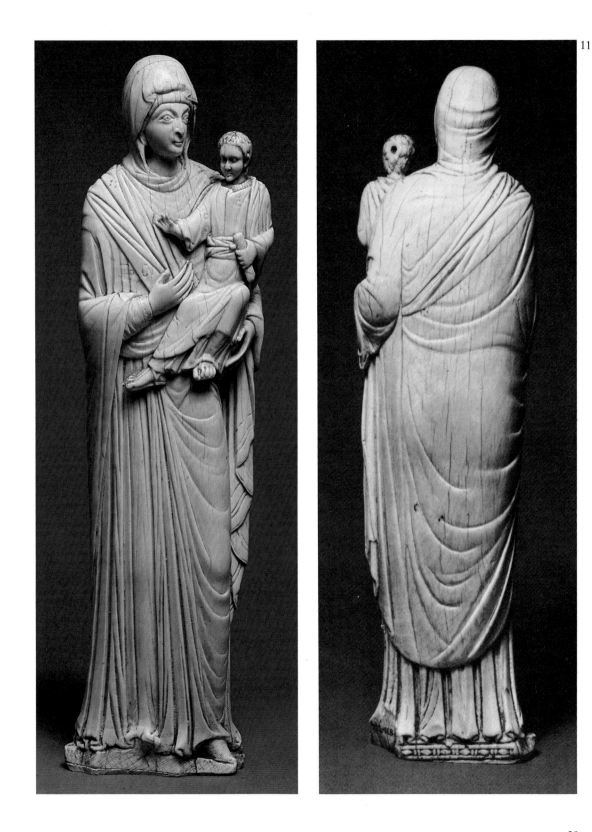

12

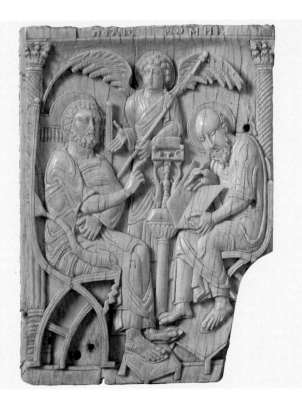

PLATE 12
Saint Peter dictating the Gospel to Saint Mark.
South Italian; late eleventh century.
H. 5¼ in, w. 4 in (13.5cm × 10cm).
270–1867

Judging from the inscription at the top of this panel, there was originally a scene above depicting the city of Rome.

13

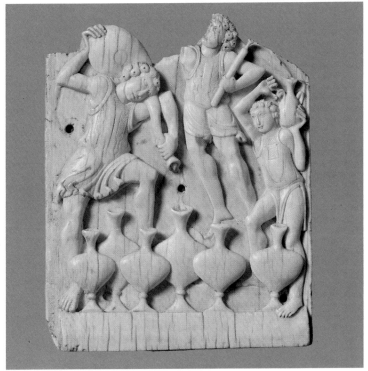

PLATE 13
The filling of the water-pots at the miracle of Cana.
South Italian; late eleventh century.
H. 4½ in, w. 3⅝ in (11.5cm × 9cm).
272–1867

By comparing this fragment with the same scene on the Salerno antependium, it is clear that the upper part of the plaque (now broken off) showed Christ amongst the guests at the Wedding-feast of Cana: the central figure is in the process of handing Him a cup of wine. See E. Maclagen, 'An Early Christian ivory relief of the Miracle of Cana', in *Burlington Magazine*, XXXVIII, 1921, pp. 178–188.

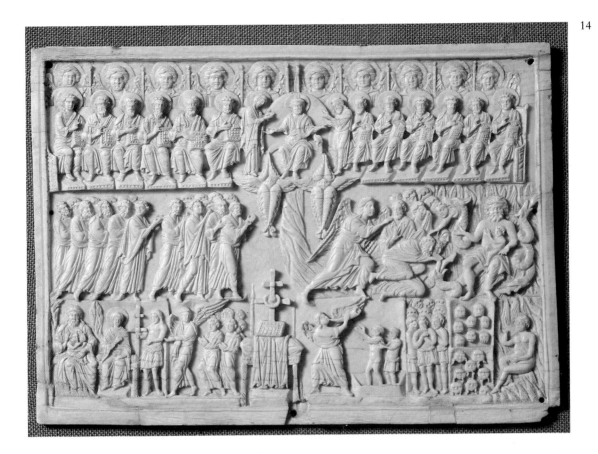

PLATE 14
The Last Judgement. Veneto-
Byzantine; twelfth century.
H. 6 in, l. 8½ in (15.5cm ×
21.5cm).
A.24–1926

Christ is seated in the centre of
the uppermost row, flanked by
the Virgin and St. John the
Baptist and surrounded by the
twelve apostles and ten angels.
From Christ's throne issues a
river of fire which feeds the
flames of Hell on the right.
Seated in the midst of the
flames is Satan, with a small
figure on his lap, and to the left
is an Archangel, who is driving
the damned into Hell. On the
left of the middle row are two
groups of the blessed: below
them an Archangel introduces
saints to the seated Virgin, who
is flanked by the penitent thief
(holding his cross) and
Abraham, with Lazarus on his
knee. In the middle is the
empty throne (the *Hetimasia*)
with the apocalyptic book of
life and the instruments of the
Passion.
See M. H. Longhurst, 'A
Byzantine ivory panel for
South Kensington', in
Burlington Magazine, XLIX,
1926, pp. 38–43.

15a

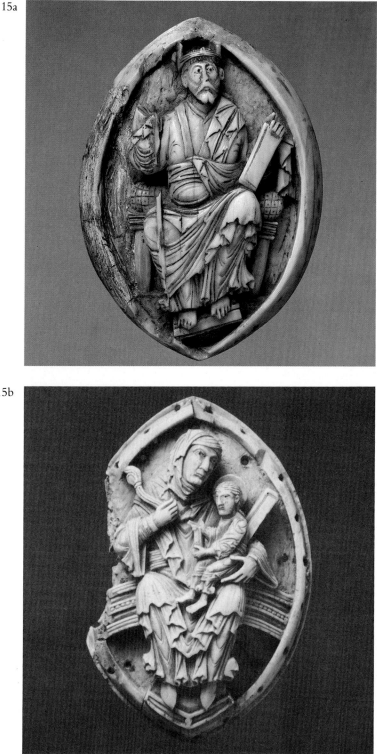

15b

PLATE 15a
Christ in Majesty. Anglo-Saxon;
early eleventh century.
Walrus ivory. H. 3¾ in
(9.5cm).
A.32–1928

Part of the left side has broken
and has been restored with
plaster.

PLATE 15b
The Virgin and Child Enthroned.
Anglo-Saxon; early eleventh
century. Walrus ivory.
H. 3⅞ in (10cm).
A.5–1935

The border and background are
pierced with small holes
probably for inlays of gold or
jewels.
It is possible that these two
reliefs formed part of a
bookcover, although the depth
of the carving would have
made them unsuitable for such
a use. They are very close in
style to the illuminations of the
Grimbald Gospels (British
Library, Add. Manuscript
34,890), which were executed
at Winchester in the first half of
the eleventh century.
See M. H. Longhurst, 'An
English Ivory for South
Kensington', in *Burlington
Magazine*, LIII, 1928,
pp. 318–321.

PLATE 16
Oval box. English; mid–
eleventh century. Walrus ivory
H. 2⅝ in, l. 2⅜ in (6.5cm ×
6cm).
268–1867

It has been suggested that the
scenes refer to a miracle of St.
Lawrence: however, the most
important episodes in this
miracle are not illustrated on
the box, and it is therefore
more likely that another, more
obscure, story is illustrated.

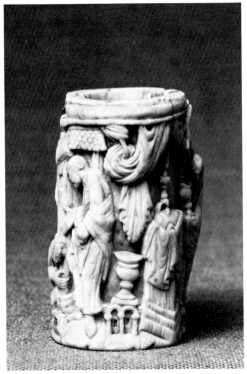

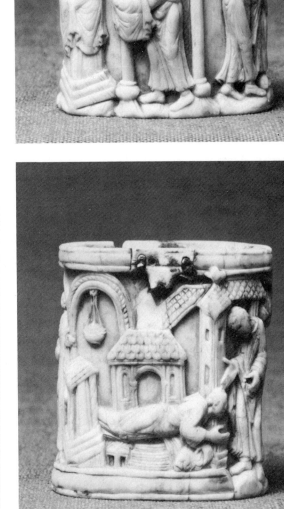

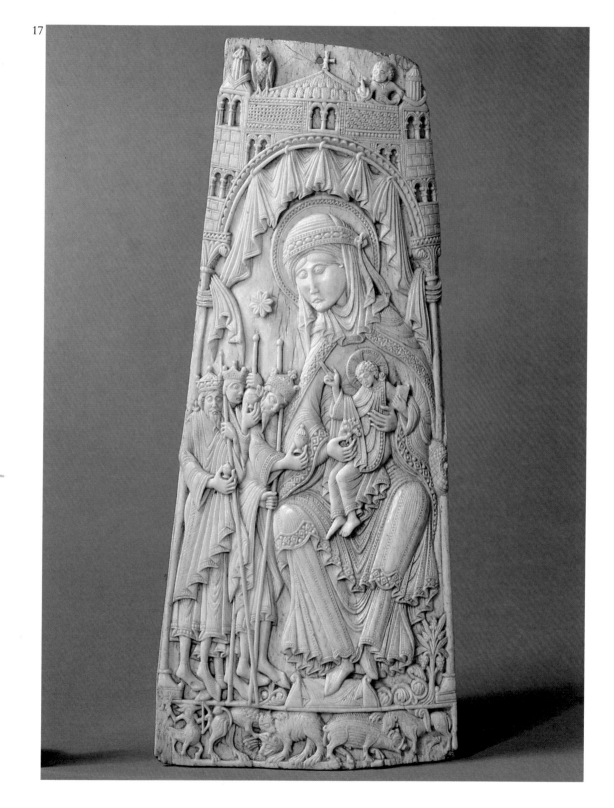

PLATE 17
The Adoration of the Magi. Probably Spanish; late eleventh century. Whalebone.
H. 14¼ in, Greatest w. 6¼ in (36.5cm × 16cm).
142–1866

The original function of this unique piece is not clear, as it is too bulky and the wrong shape to have been attached to a bookcover. See page 16. See J. Hunt, 'The Adoration of the Magi', in *The Connoisseur*, CXXXIII, 1954, pp. 154–161; Carmen Bernis, 'La Adoracion de los Reyes del siglo XII del Museo Victoria y Alberto es des escuela española', in *Archivio español de Arte*, XXXIII, 1960, pp. 82ff; J. Beckwith, *The Adoration of the Magi in Whalebone*, Victoria & Albert Museum, 1966.

PLATE 18
Pectoral cross. English (Canterbury); about 1100. Walrus ivory.
H. 4¾ in, w. 1⅞ in, d. 1⅛ in (11.9cm × 4.6cm × 2.7cm).
A.6–1966

On the lid is an archer (probably to be identified as Ishmael, son of Abraham and Hagar), aiming at a bird: on the back is the Lamb of God surrounded by the four symbols of the Evangelists. The cross originally formed a case for a gold box, which would have contained relics or a fragment of the True Cross.
See J. Beckwith, 'A rediscovered English reliquary cross', in *Victoria & Albert Museum Bulletin*, II, 1966, pp. 117ff.

18

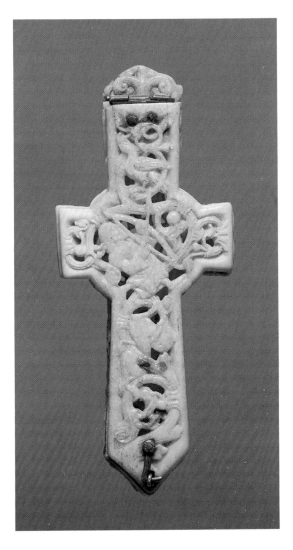

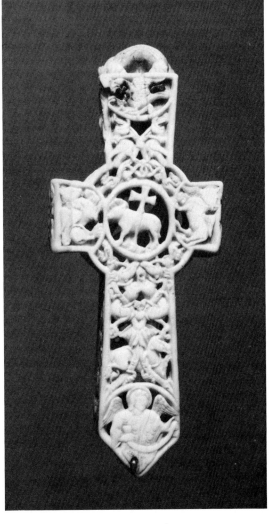

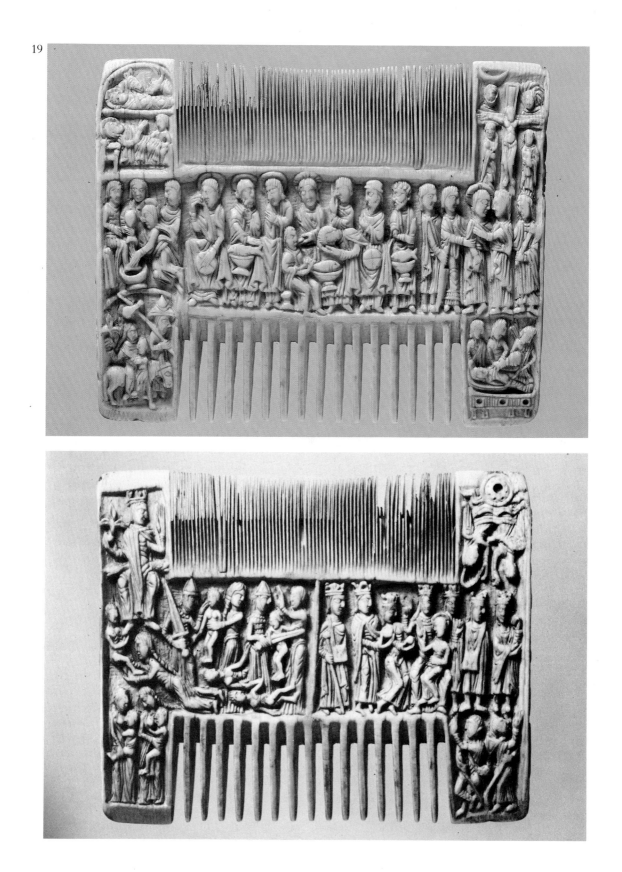

PLATE 19
Liturgical comb. English (St Albans); about 1120.
H. 3⅜ in, w. 4½ in (8.5cm × 11.5cm).
A.27–1977

On one side, the Nativity, the Flight into Egypt, the Washing of the Feet of the Disciples, the Last Supper, the Betrayal, the Crucifixion, and the Entombment: on the other side, the Massacre of the Innocents, the Adoration of the Magi, the Journey of the Magi, and the Annunciation to the Shepherds.

PLATE 20a
The Nativity. German (Cologne); second quarter of the twelfth century. Walrus ivory.
H. 8¼ in, w. 7½ in (21cm × 19cm).
144–1866

PLATE 20b
The Ascension. German (Cologne); second quarter of the twelfth century. Walrus ivory.
H. 8⅜ in, w. 7⅝ in (21.5cm × 19.5cm).
378–1871
It is most likely that these two panels formed part of a large altar-frontal, as other panels of the same size and in the same style still exist in the Victoria & Albert Museum and the Metropolitan Museum in New York.

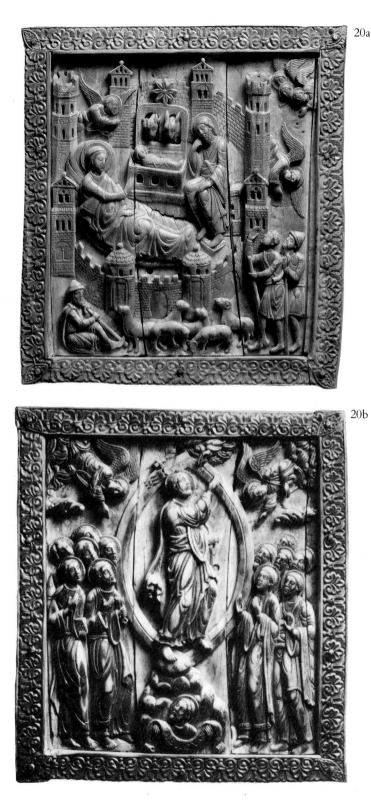

20a

20b

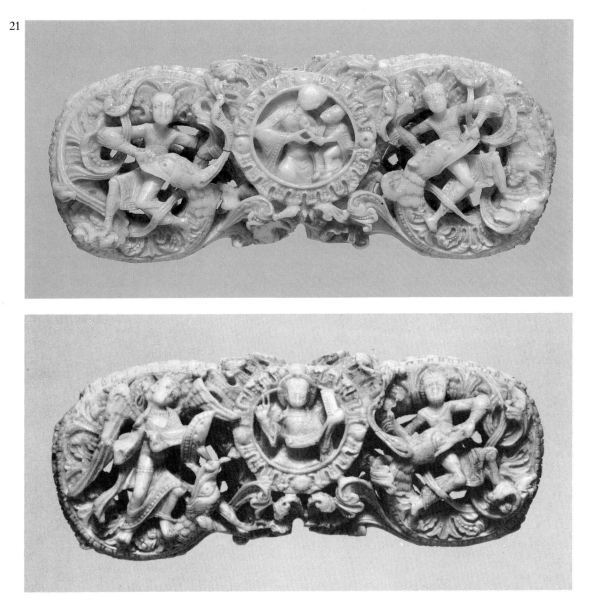

PLATE 21
Head of a Tau-cross. English (Winchester); about
1140. Walrus ivory.
H. 2¼ in, l. 6⅜ in (5.5cm × 16.5cm).
371–1871

On one side is the Virgin and Child between two
men struggling with serpents: on the other side,
Christ is shown blessing with his right hand and
holding a book in his left; St. Michael subdues a
dragon to Christ's left, and to the right another
man struggles to free himself from the jaws of a
serpent.

PLATE 22
The Virgin and Child. English (Dorchester ?);
middle of the twelfth century. Walrus ivory.
H. 5⅝ in, w. 2½ in (13.5cm × 6.4cm).
A25–1933

The Virgin and Child originally formed part of an
Adoration of the Magi group: one of the magi still
survives, and is now in the Dorset County
Museum in Dorchester.
See M. H. Longhurst, 'A Twelfth century English
Ivory', in *Burlington Magazine*, LXIV, 1934,
pp. 139–140.

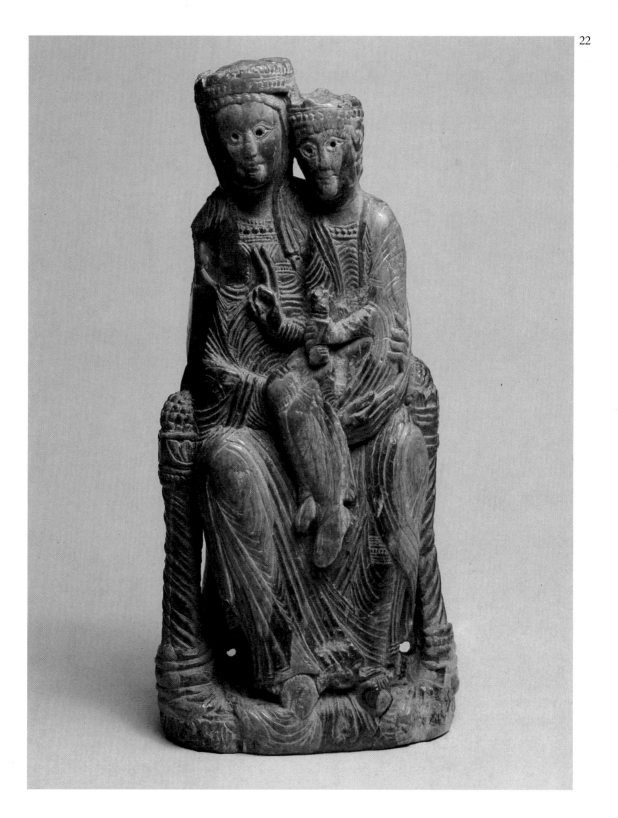

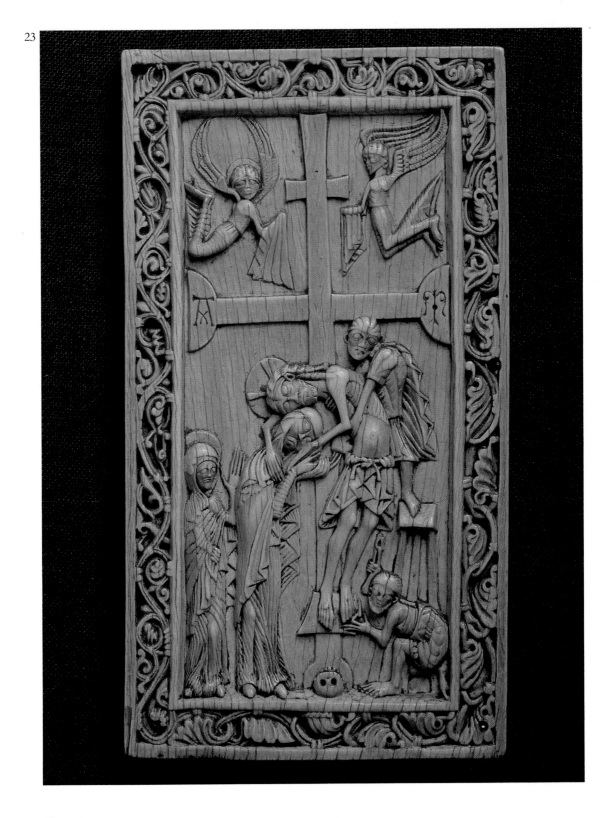

PLATE 23
The Deposition. Spanish or English (Herefordshire
School); about 1150.
H. 8⅜ in, w. 4⅝ in (21.5cm × 12cm).
3–1872

See page 16, and J. Beckwith, 'An Ivory Relief of
the Deposition', in *Burlington Magazine*, XCVIII,
1956, pp. 228ff.

PLATE 24
The St. Nicholas Crozier. English; about 1180.
H. 4¾ in, W. 4¼ in (12cm × 11cm).
218–1865

The crozier shows scenes from the Nativity and
the Life of St. Nicholas.
See W. S. Dale, 'An English Crozier of the
Transitional Period', in *Art Bulletin*, XXXVIII, 1956,
pp. 137ff.

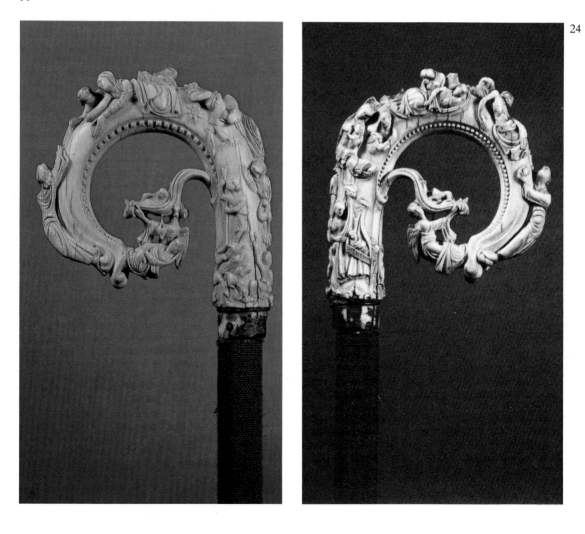

24

PLATE 25
Diptych of Christ blessing and the Virgin and Child.
English; early fourteenth century.
H. 8½ in, w. 6⅜ in (21.6cm × 16.2cm).
A.545–1910.

The inscription in the book Christ is holding reads:
EGO SU[m] D[omi] N[u]S D[eu]S TUUS I[hsov] C XP
[isto]C Q[ui] CREAVI REDEMI ET SALVABO TE.

PLATE 26
The Soissons Diptych. French (Paris); late thirteenth
century. H. 12¾ in, w. (each leaf) 4½ in (32.4cm
× 11.4cm).
211–1865

The diptych shows scenes from the Passion of
Christ and should be read across the leaves,
starting from the lower left corner, and back again.

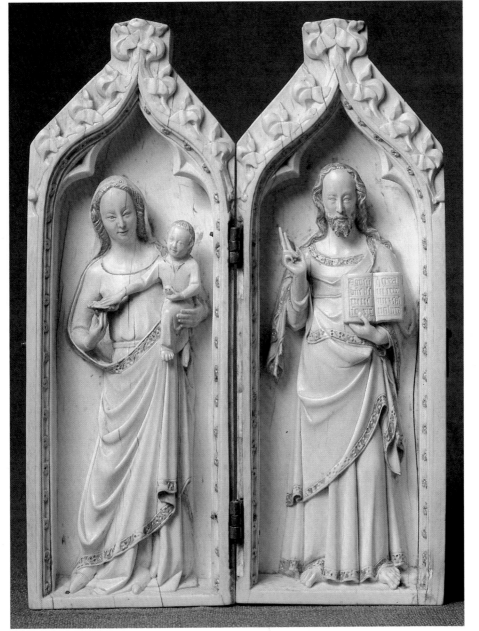

25

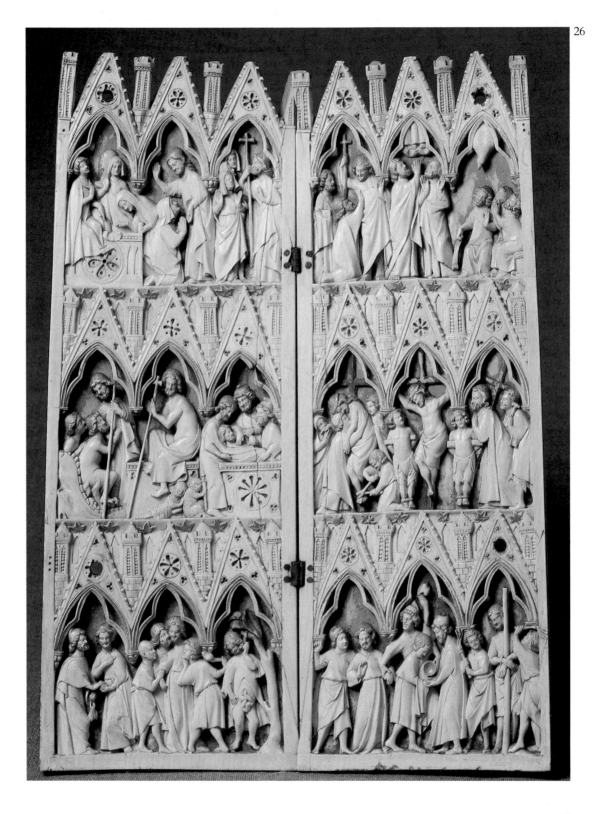

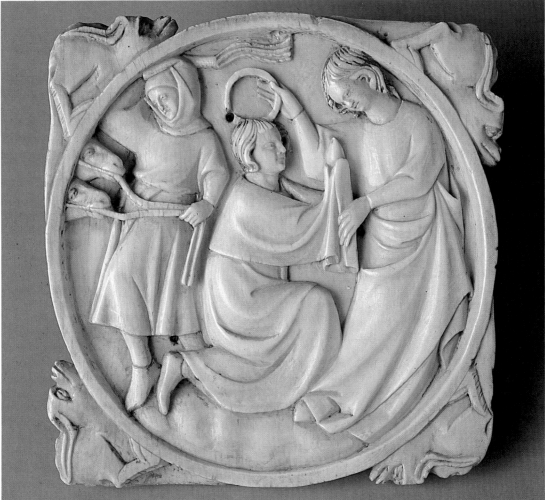

PLATE 27
Mirror case. French (Paris); around 1300.
D. 4⅛ in (10.5cm).
217–1867

A lady crowns her lover who kneels before her: on
the left a servant holds two horses. On the rim are
four crawling monsters.

PLATE 28
A Pope. French; second quarter of the thirteenth
century.
H. 6in (15.5cm).
A.8–1914

This figure formed part of a large composition, as
can be seen by the flattened back and the remains
of a dowel and pin (indicating that it was originally
fixed to a background). The large-scale appliqué
figure ceased to be used in the fourteenth century.

PLATE 29
The Virgin and Child. French (Paris); early fourteenth
century.
H. (including base) 16in, w. 3½ in (40.6cm ×
8.9cm).
4685–1858

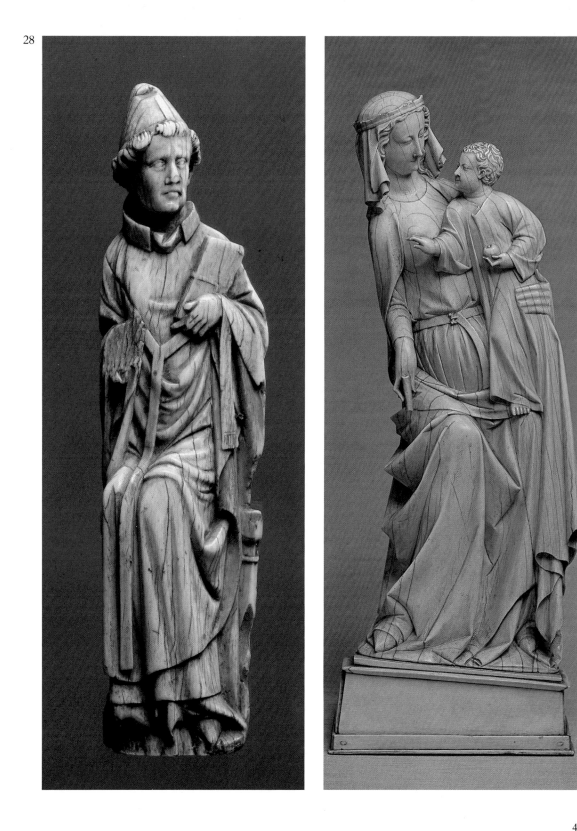

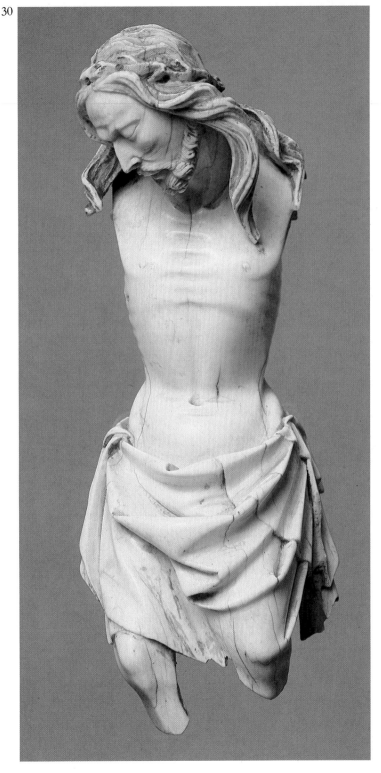

PLATE 30
Torso of Christ. Italian; around 1300.
H. 6in (15.5cm).
212–1867

This beautifully carved small figure of Christ has been convincingly attributed to Giovanni Pisano, on the strength of resemblances to his work in both wood and marble. See J. Pope-Hennessy, 'An Ivory by Giovanni Pisano', in *Victoria & Albert Museum Bulletin*, I, 1965, iii, pp. 9ff.

Further Reading

Four indispensable catalogues cover medieval ivory carving: for the ivories of the Early Christian period, see W. F. Volbach, *Elfenbeinarbeiten der Spätantike und des frühen Mittelalters*, Mainz, 1976, 3rd edition. The Carolingian, Ottonian, and Romanesque carvings are treated in A. Goldschmidt, *Die Elfenbeinskulpturen aus der Zeit der karolingischen und sächsischen Kaiser*, Berlin, 1914–26, 4 volumes. For Byzantine ivories see A. Goldschmidt and K. Weitzmann, *Byzantinische Elfenbeinskulpturen*, Berlin, 1930–34, 2 volumes. R. Koechlin, *Les Ivoires Gothiques Français*, Paris, 1924, 3 volumes, is still the standard work on Gothic ivory carvings.

Anglo-Saxon and later English ivory carvings are discussed in detail in M. Longhurst, *English Ivories*, London, 1926, and J. Beckwith, *Ivory Carvings in Early Medieval England*, London, 1972. The early literary references to ivory are to be found in G. C. Williamson, *The Book of Ivory*, London, 1938, and there is much useful information in W. Maskell, *Ivories*, London, 1905. J. Natanson gives a concise introduction to Gothic and Early Christian ivories in two small books, *Gothic Ivories of the 13th and 14th centuries*, London, 1951, and *Early Christian Ivories*, London, 1953. A good recent survey of medieval ivory carving is by D. Gaborit-Chopin, *Ivoires du Moyen Age*, Fribourg, 1978.

Nearly all the ivories illustrated in this book are discussed in M. Longhurst, *Catalogue of Carvings in Ivory, Victoria and Albert Museum*, London, I, 1927, II, 1929.

Note

All the ivories illustrated are discussed in the relevant books mentioned above: if an article has dealt exclusively with any one ivory, it is referred to in the caption.

Unless stated otherwise, the ivory is elephant ivory.